P9-BHZ-491

My Mom
is a Dragon

And My Dad Is A Boar

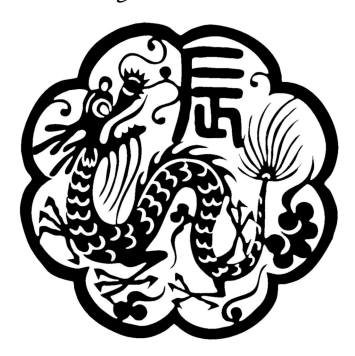

By Tricia Morrissey

Chinese Paper Cut Art and the Twelve Lunar Animals

THINGSASIAN KIDS

My Mom Is A Dragon And My Dad Is A Boar
By Tricia Morrissey

Cover and book design by Janet McKelpin

Copyright ©2005 ThingsAsian Press
All rights reserved under international copyright conventions. No part of
the contents of this book may be reproduced or utilized in any form or by any
means, electronic or mechanical, including photocopying and recording, or
by any information storage and retrieval system, without the written consent
of the publisher.

For information regarding permissions, write to:
ThingsAsian Press
3230 Scott Street
San Francisco, California 94123 USA
info@thingsasianpress.com
www.thingsasianpress.com

Printed in Singapore

0-9715940-5-8
978-0-9715940-5-0

"You cannot keep the birds of misfortune from flying over your head, but you can keep them from building nests in your hair."

— Chinese Proverb

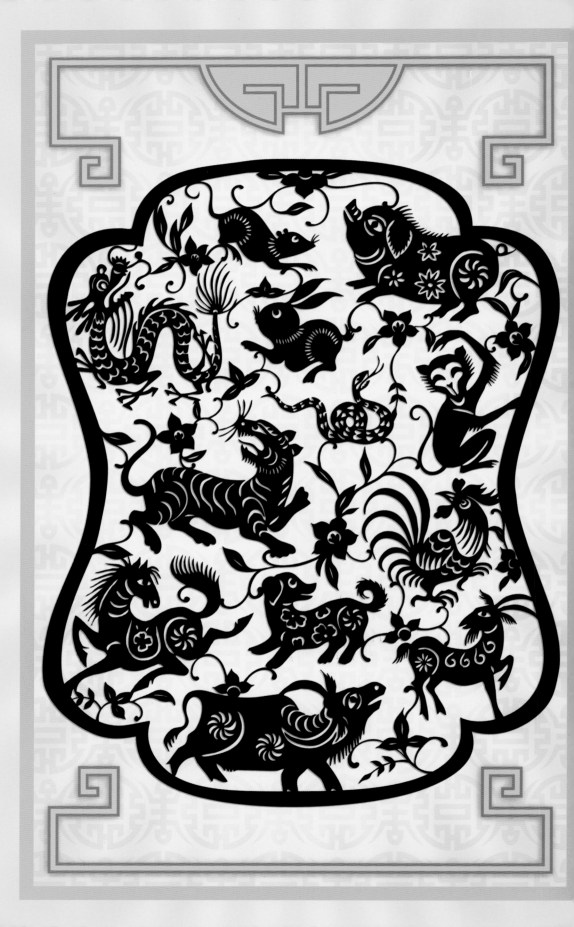

My mom is a Dragon and my dad is a Boar. What am I? According to the Chinese lunar calendar, I was born in the year of the Rat. The calendar divides time into sets of twelve years, with each year named after a special animal. Listen to the story of how twelve lucky animals came to symbolize the twelve years of the Chinese lunar calendar.

One fine day, the Lord Buddha sent an announcement to all the animals. He would name one year of the calendar after each of the first twelve animals to set paw, horn or whisker in his court. Year after year, people would remember and celebrate these animals. They would cook feasts, they would pound drums, they would dance. However, only the first twelve to arrive would receive this splendid honor.

The race was on and the animals prepared for the journey to Buddha's court. The Rat and the Cat decided to go together. In spite of this friendly plan, the Rat crept away early in the morning. With no one to wake him, the Cat slept and slept. The sun shining in his eyes, he woke to find the Rat had left him behind.

The clever Rat knew the larger animals could travel quickly. So, still full of trickery, he convinced the Ox to carry him. The Rat rode on the Ox through fields and rivers. When they finally neared the court, the Rat jumped from the Ox's head and scampered to the Lord Buddha first.

The Ox arrived next, followed by the Tiger, the Rabbit, the Dragon, the Snake, the Horse, the Sheep, the Monkey, the Rooster, the Dog, and finally, the Boar. The sleepy Cat came too late and did not receive a year. Some say this is the reason cats have always chased rats.

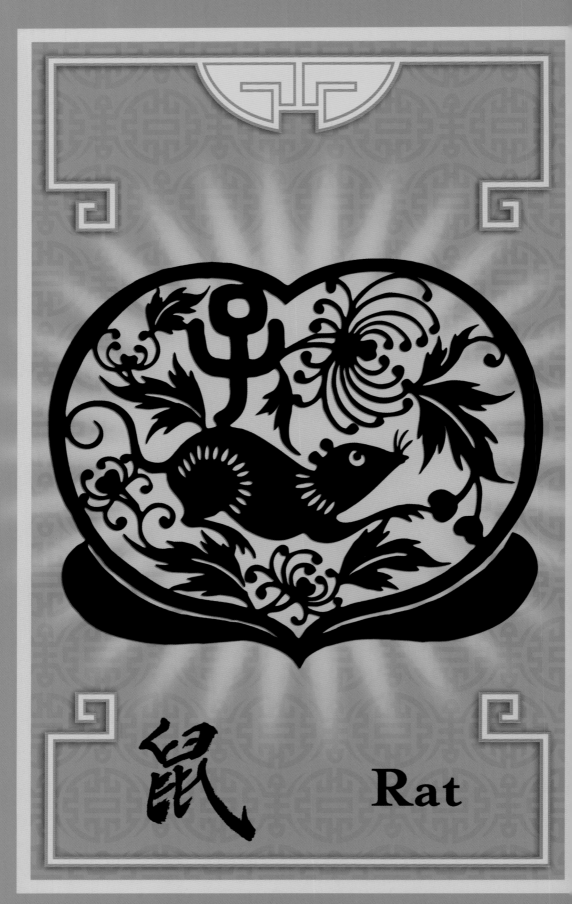

鼠　Rat

The crafty Rat sees chance dancing in every corner. She carefully hoards her finds, keeping bits of treasure and trash for a rainy day. In spite of her careful, thrifty ways, the Rat has many friends. Her clever charm and dazzling ambition are hard to resist.

YEAR OF THE RAT
1924, 1936, 1948, 1960, 1972,
1984, 1996, 2008, 2020, 2032

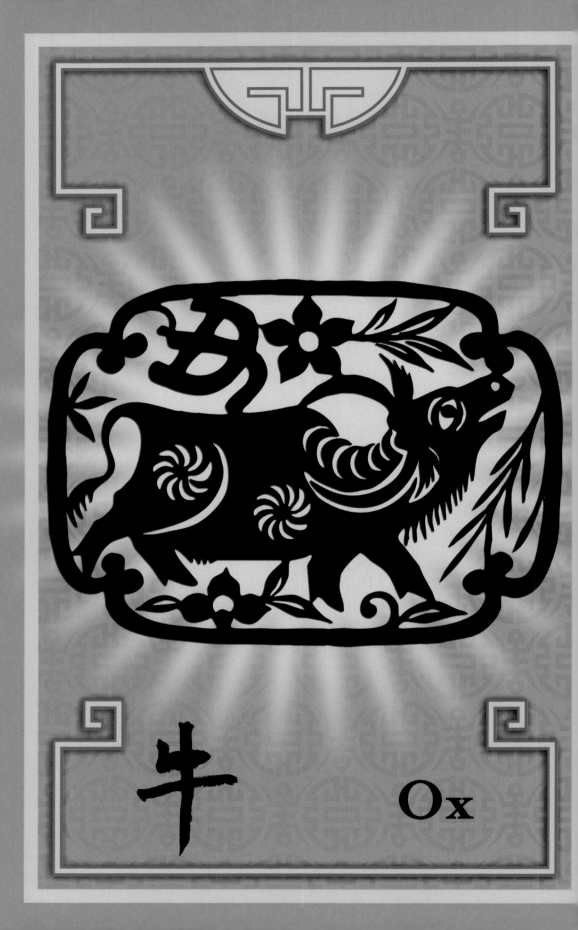

牛 Ox

The stubborn Ox is patient and hardworking. He thinks carefully, tries to help others and marches through trouble one hoof at a time. On the outside he seems simple and slow, but he is always listening closely and pondering quietly. You can depend on the Ox!

Year of the Ox
1925, 1937, 1949, 1961, 1973,
1985, 1997, 2009, 2021, 2033

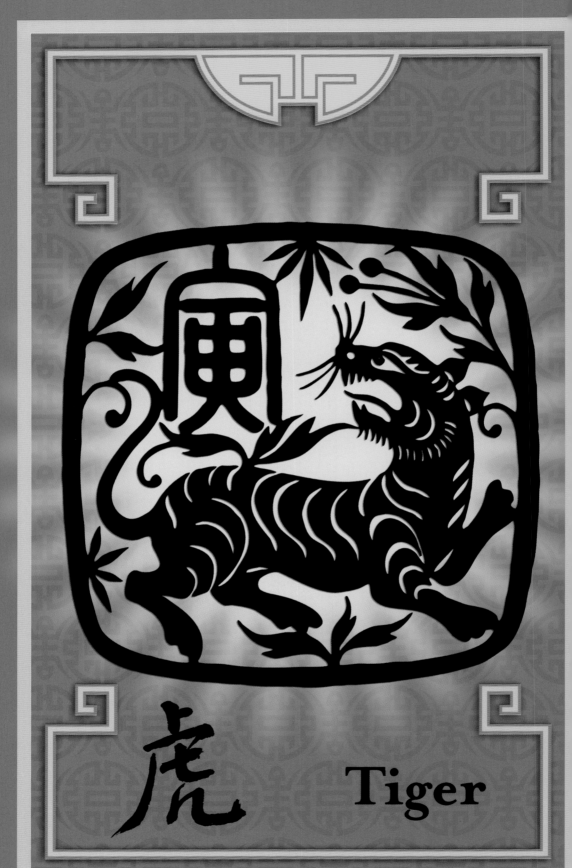

虎　Tiger

The fearless Tiger roars and everyone wakes up. He is courageous, powerful and always prowling. You never know what the Tiger will do. He leaps forward and leaves havoc in his wake. Sometimes, even he is sorry. Still, the Tiger is clever and full of laughter. Beware of his wild and merry ways; they are contagious.

Year of the Tiger
1926, 1938, 1950, 1962, 1974,
1986, 1998, 2010, 2022, 2034

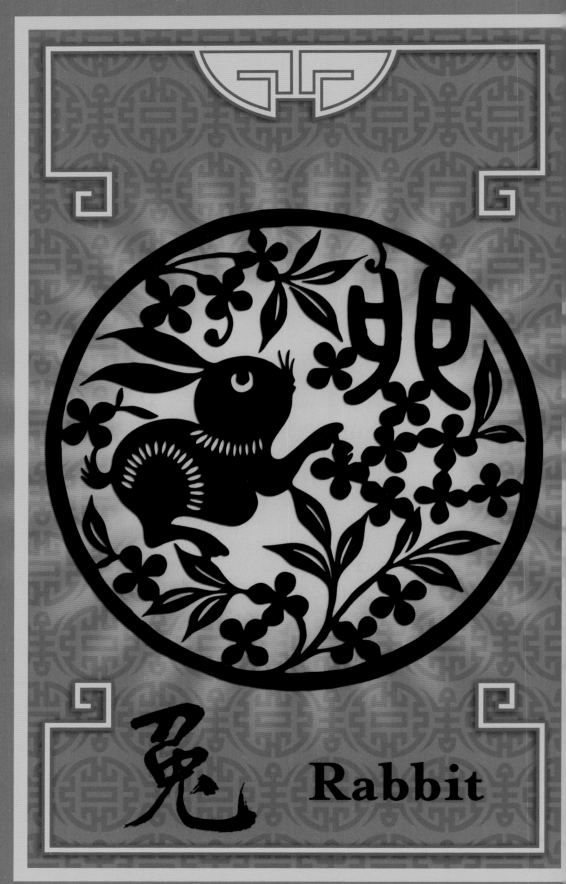

兔 Rabbit

The nimble Rabbit loves beauty and has impeccable manners. Peaceful and friendly, the Rabbit hops in and out of the ruckus but never bullies. The Rabbit likes to be comfortable, ignoring silly problems as long as possible. Friendships surround the Rabbit, whose neighbors receive good advice and kindness.

Year of the Rabbit

1927, 1939, 1951, 1963, 1975, 1987, 1999, 2011, 2023, 2035

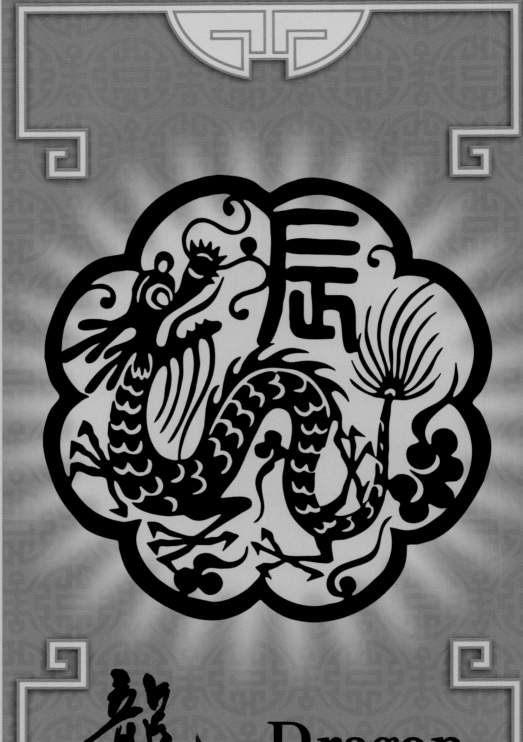

龍 Dragon

Explosion and excitement
follow the Dragon wherever
she goes. With a hasty temper
and shrewd confidence, she
throws caution to the wind.
The Dragon is whimsical,
wild and unstoppable.
She pays no attention to
mistakes, but blazes forward
with mighty enthusiasm.
Do not get in her way,
but enjoy her from afar
with wide open eyes.

Year of the Dragon
1928, 1940, 1952, 1964, 1976,
1988, 2000, 2012, 2024, 2036

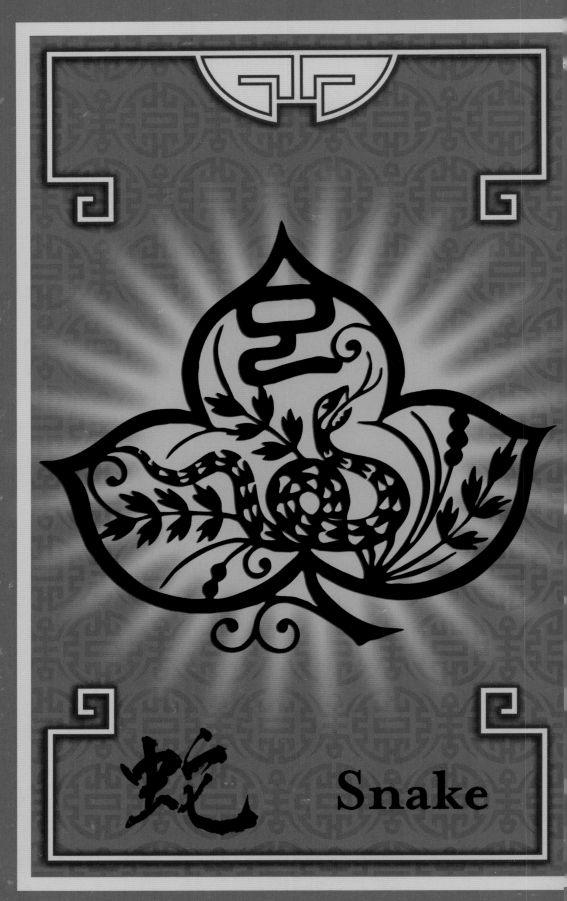

蛇　Snake

The mysterious Snake is
wise and unpredictable.
He spies everything, moves
gracefully and acts swiftly.
You never know what the
silent Snake is planning,
but you know he is always
thinking. Exciting, dangerous
and shrewd, the Snake
invites caution.

Year of the Snake
1929, 1941, 1953, 1965, 1977,
1989, 2001, 2013, 2025, 2037

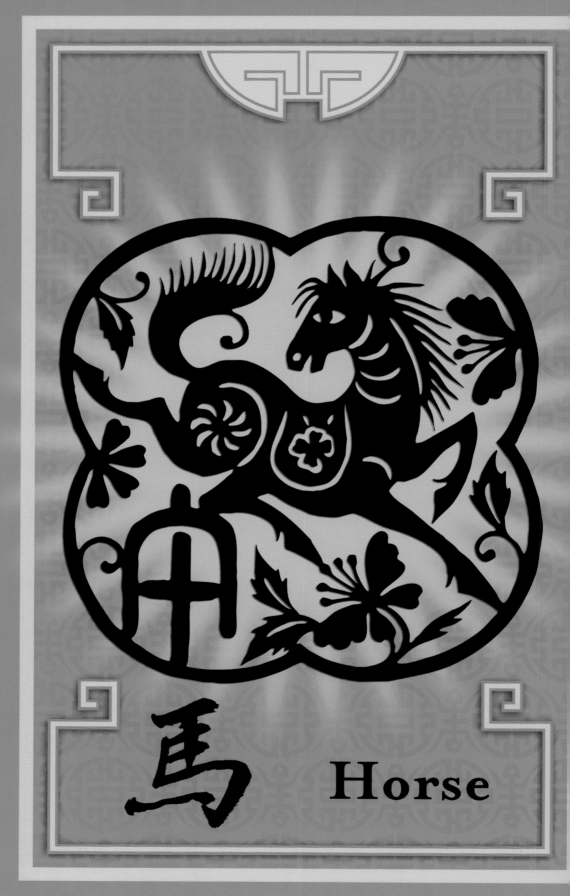

馬 Horse

The lively Horse follows no
rules. She bolts with grace
and flies on four legs. She is
sorely disappointed when
others fall behind. A storm
of activity, reckless and
high-spirited, she likes to
have her own way. Let the
Horse run free and she is
superbly happy. Stop to catch
your breath and she is gone.

Year of the Horse

1930, 1942, 1954, 1966, 1978,
1990, 2002, 2014, 2026, 2038

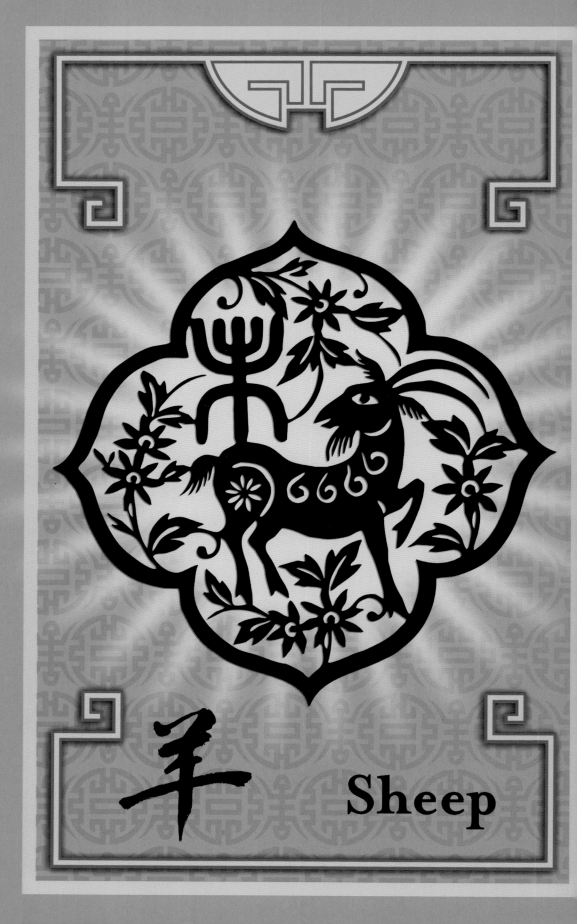

羊 Sheep

Gentle and kind, the Sheep
invites peace. He forgives
easily, collecting a bounty
of friends and few enemies.
Carefree, and a little lazy,
the Sheep shies away from
troublesome work. Even so,
his patient friends always
take care of him, and he finds
he has everything he needs.

Year of the Sheep
1931, 1943, 1955, 1967, 1979,
1991, 2003, 2015, 2027, 2039

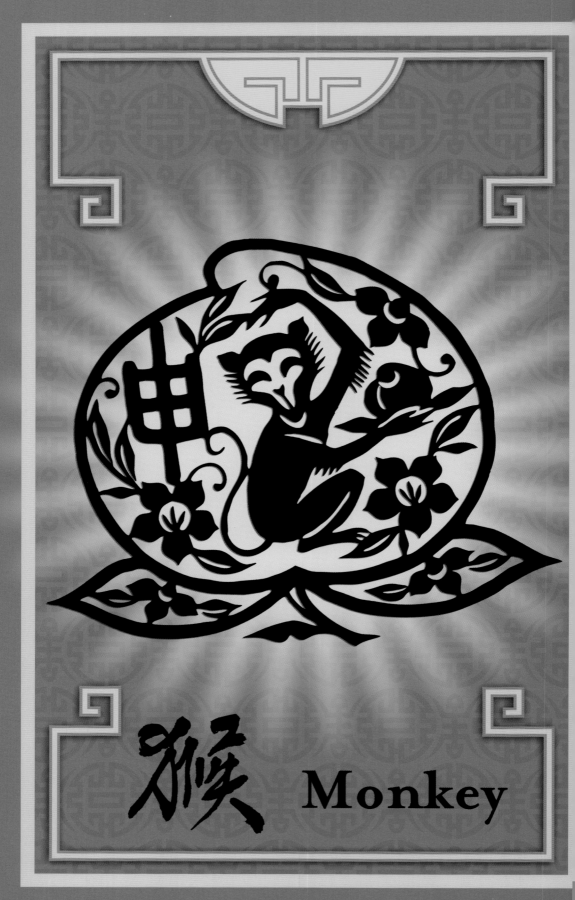

猴 Monkey

Lively and funny, the clever Monkey bursts with impossible ideas. She is delighted by her own genius, tickled by her nimble spirit and silly imagination. The Monkey rarely looks back, but swings eagerly from success to success. You should never try to trick the Monkey. But you will like the Monkey even after she has tricked you.

Year of the Monkey
1932, 1944, 1956, 1968, 1980,
1992, 2004, 2016, 2028, 2040

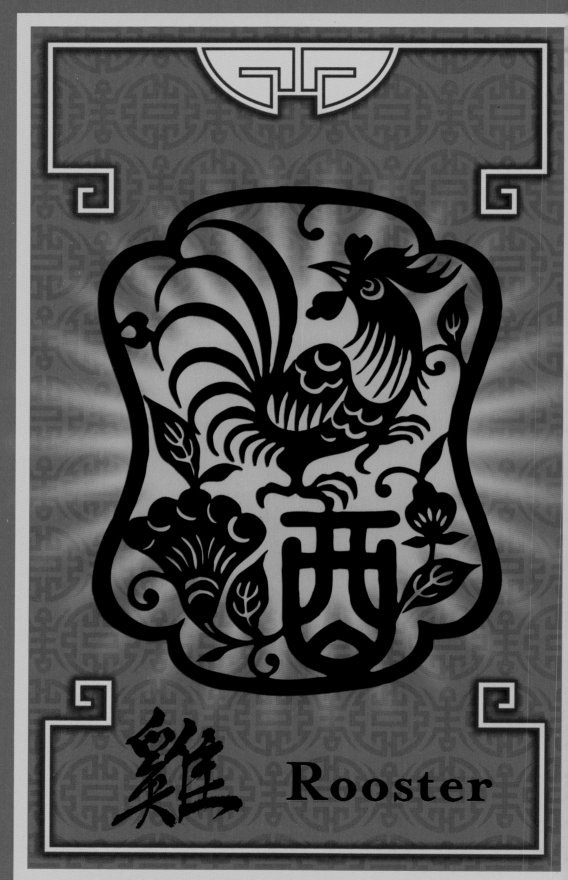

雞　Rooster

The colorful Rooster has
high, noisy hopes. He
spreads his tail feathers and
crows with excitement,
announcing, loudly, that he
is in charge. Sometimes he
makes a mess of things,
turning simple ideas into
puzzling plans. But the
Rooster is resourceful, so
his days are happy and
he never goes hungry.

Year of the Rooster
1933, 1945, 1957, 1969, 1981,
1993, 2005, 2017, 2029, 2041

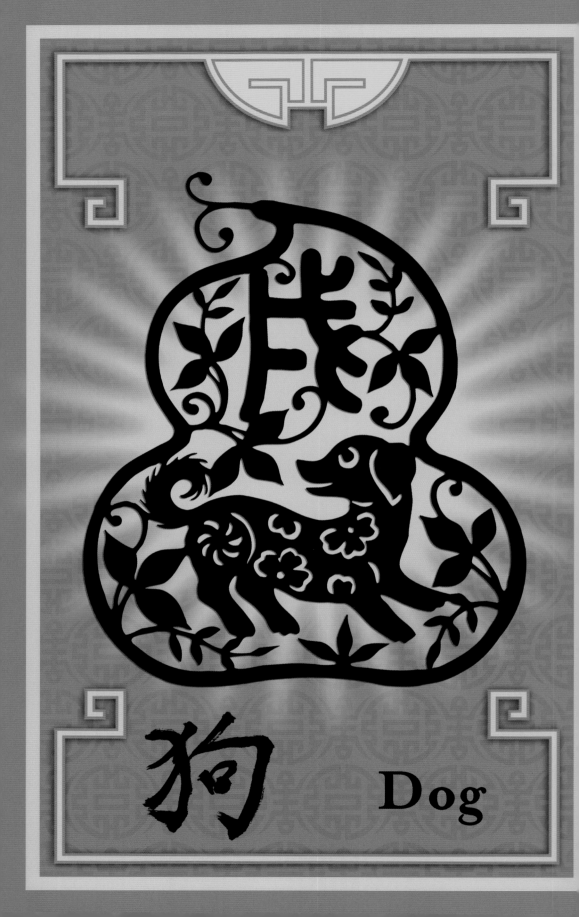

狗

Dog

Honest and loyal, the
Dog stands guard. She is
watchful, alert and ready
to protect her friends.
Everyone likes the Dog,
with her kind service and
wagging tail. Her keen eyes
and wise heart know the
difference between right
and wrong. Your secrets
are safe with her.

Year of the Dog
1934, 1946, 1958, 1970, 1982,
1994, 2006, 2018, 2030, 2042

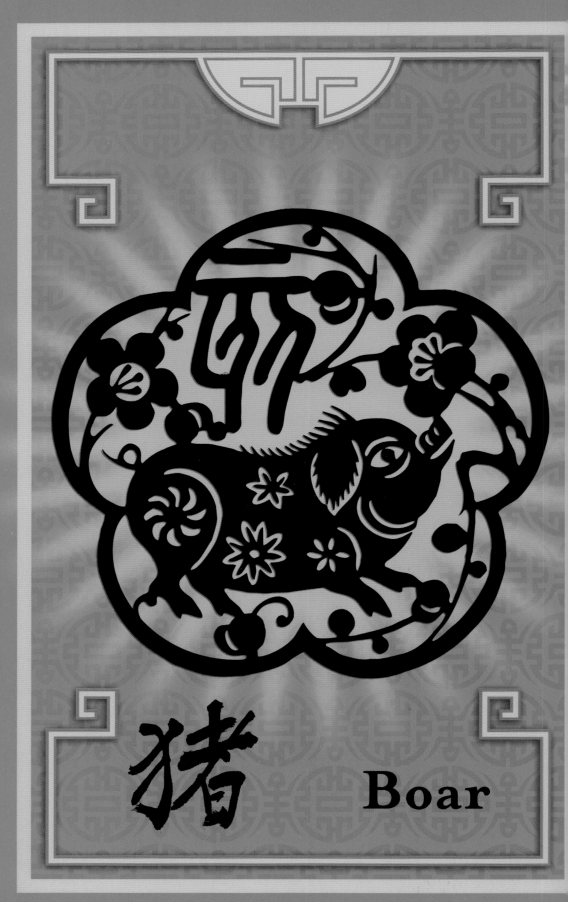

猪 Boar

The honest and steady Boar
throws his heart and snout
into every task. He works
hard but relishes fun,
discovering a feast and a
friend around every corner.
The Boar likes to share
his happiness and gives
big presents for small
reasons. When the Boar
visits, everyone is
welcome to the party.

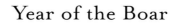

Year of the Boar

1935, 1947, 1959, 1971, 1983,
1995, 2007, 2019, 2031, 2043

Chinese noblewomen began creating paper cut art during the Han dynasty (206 B.C. – 221 A.D.). To pass time, ladies of the court would cut pictures of flowers and animals from paper, a newly invented, delicate material. They used these precious paper decorations to brighten their hair and clothes. They also gave them to each other as gifts.

Over many centuries, as papermaking skills spread, girls throughout China learned to snip intricate pictures from paper. In addition to sewing and cooking, families expected girls to be able to decorate a home with paper cut art.

Today, paper cut art is still used as decoration, especially on windows and lanterns. It is given as gifts and used as embroidery patterns. If you visit China, look down at a lady's feet. You may find a paper cut flower pattern sewn onto a silk slipper.

Paper cut artists use small, sharp scissors, or a knife, to cut through the fragile paper. Each paper cut picture is unique, depending on the mood, skill and region of the artist. The style of paper cut art featured in this book is from the Nanjing Province in China.

For more information about Asia and
Asia-related activities for kids, visit
ThingsAsian.com

Twelve Lunar Animals

Paper Cut Art

Tricia Morrissey was born in Nairobi, Kenya in
the year of the Rat. She currently lives in San
Francisco, California, where she is visited by
woodland creatures and children on a regular
basis. She enjoys the company of both.

The calligraphy featured in this book was
created by calligrapher and artist Kong Lee.

Kong Lee was born in Guangzhou, China, but
grew up in Hong Kong. In 1973, he moved with
his family to California. His love for Chinese
calligraphy, brush painting, and photography
began at a very young age. Mr. Lee's work,
which is inspired by his love of travel, has been
exhibited throughout China and California.

Printed and bound by Tien Wah Press, Singapore
Book design by Janet McKelpin
Book production by Paul Tomanpos, Jr.